ANCIENT MEXICAN DESIGNS

CD-ROM AND BOOK

DOVER PUBLICATIONS, INC.
MINEOLA, NEW YORK

The CD-ROM on the inside back cover contains all of the images shown in the book. There is no installation necessary. Just insert the CD into your computer and call the images into your favorite software (refer to the documentation with your software for further instructions). Each image has been scanned at 600 dpi and saved in six different formats—BMP, EPS, GIF, JPEG, PICT, and TIFF. The JPEG and GIF files—the most popular graphics file types used on the Web—are Internet-ready.

The "Images" folder on the CD contains a number of different folders. All of the TIFF images have been placed in one folder, as have all of the PICT, all of the EPS, etc. The images in each of these folders are identical except for file format. Every image has a unique file name in the following format: xxx.xxx. The first 3 or 4 characters of the file name, before the period, correspond to the number printed with the image in the book. The last 3 characters of the file name, after the period, refer to the file format. So, 001.TIF would be the first file in the TIFF folder.

Also included on the CD-ROM is Dover Design Manager, a simple graphics editing program for Windows that will allow you to view, print, crop, and rotate the images.

For technical support, contact:
Telephone: 1 (617) 249-0245
Fax: 1 (617) 249-0245
Email: dover@artimaging.com
Internet: **http://www.dovertechsupport.com**
The fastest way to receive technical support is via email or the Internet.

Copyright
Copyright © 1999 by Dover Publications, Inc.
Electronic images copyright © 2002 by Dover Publications, Inc.
All rights reserved.

Bibliographical Note

Ancient Mexican Designs CD-ROM and Book, contains all of the images shown in the book *Ancient Mexican Designs* by Gregory Mirow, originally published by Dover Publications, Inc., in 1999.

Dover Electronic Clip Art®

These images belong to the Dover Electronic Clip Art Series. You may use them for graphics and crafts applications, free and without special permission, provided that you include no more than ten in the same publication or project. For permission for additional use, please write to Permissions Department, Dover Publications, Inc., 31 East 2nd Street, Mineola, New York 11501.

However, republication or reproduction of any illustration by any other graphic service, whether it be in a book, electronic, or in any other design resource, is strictly prohibited.

International Standard Book Number: 0-486-99528-3

Manufactured in the United States of America
Dover Publications, Inc., 31 East 2nd Street, Mineola, N.Y. 11501

PUBLISHER'S NOTE

The ancient designs of Mexico represent the artistic traditions of the many different peoples who have lived in the area, dating back thousands of years before the arrival of the European explorers. Among the dominant pre-Columbian groups were the earliest known civilization, the Olmecs, who lived on the Gulf Coast and adjoining lands c. 1400–200 B.C.; the people (of still-unknown origin) who, beginning in the 1st century A.D., built Teotihuacán, the monumental urban complex still being excavated near present-day Mexico City; the Maya, who flourished in the Yucatán and in the south c. 300–900; and the Aztecs, who migrated from the north to the Valley of Mexico around 1300. There were others as well—among them Zapotecs, Mixtecs, and Toltecs—who created works of art that, once uncovered, stun the modern imagination. The art and design of the ancient Mexicans sprang from many sources. Religion, of course, was of supreme importance. Representations of gods, mystical symbols, and objects used in sacred ceremonies have been found in great profusion by archaeologists. Quetzalcóatl, the plumed serpent, and other gods in the Mexican pantheon are a recurring theme in Olmec, Aztec, and other ancient Mexican art. Kings and ordinary people, animals and plants—sometimes fanciful, sometimes representational—were also favorite subjects for early artists and artisans.

A number of sites have proven to be especially rich sources of pre-Columbian art and architecture. In addition to Teotihuacán, Tlatilco, and later Aztec cities such as Tenochtitlán—all in the vicinity of present-day Mexico City—Palenque, Chichén Itzá, and other Mayan centers, along with Oaxaca, Monte Albán, and Vera Cruz, are also important. Whenever possible, the original geographic source of the designs in this book has been noted in the captions. Other, more specific sources are also credited. Some designs have been taken from ancient Mexican manuscript books, called codices and comprised of painted pictographs, ideograms, and phonetic symbols. Although many of these works were destroyed by Spanish missionaries, who believed them to be blasphemous, a few were preserved and taken back to Europe. They all were named, mostly for places or people; thus, the Madrid Codex is in the custody of the Museo de América in Madrid.

Academicians have divided the history of Mesoamerica into three major periods: Pre-Classic (or Formative), from about 1500 B.C. until A.D. 100; Classic, from 100 until 900; and Post-Classic, from 900 until the Spanish arrived in 1519. The 240 designs in this book are taken from works of art created in all these periods—over 3,000 years of human civilization. Virtually ignored for centuries, the rich heritage of ancient Mexican civilizations offers a treasure trove of inspiration and delight to artists, designers, and connoisseurs alike.

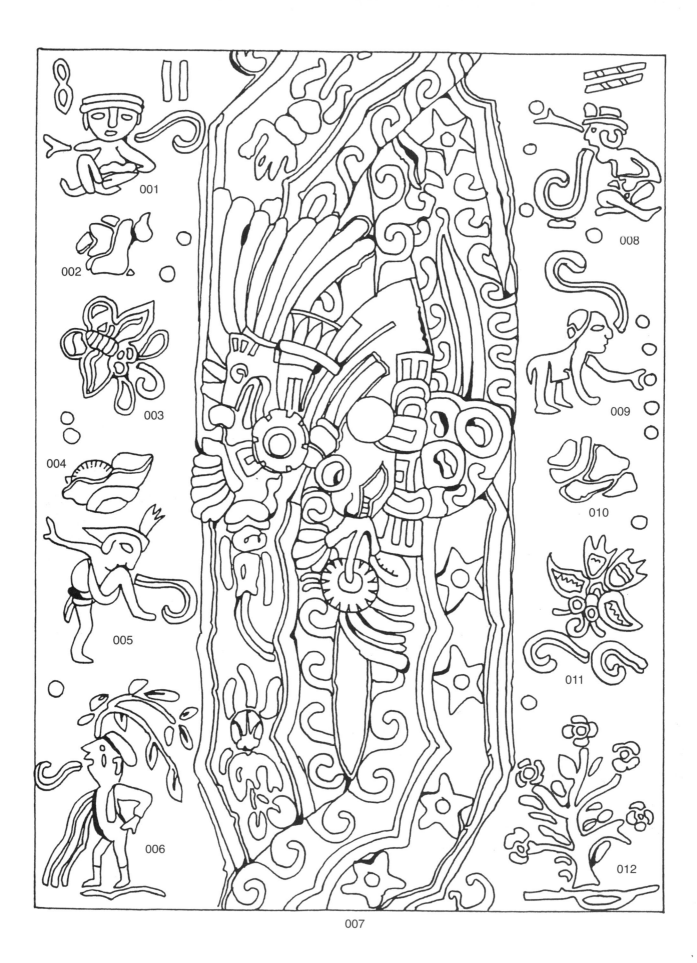

001

002

003

004

005

006

007

008

009

010

011

012

Mural, "Rain God's Heaven"; Teotihuacán.

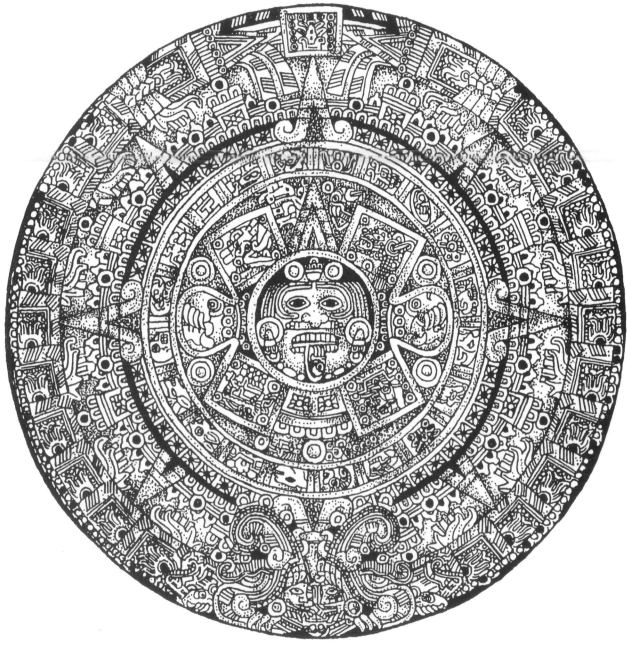

013

Aztec calendar stone, reign of Axayacatl.

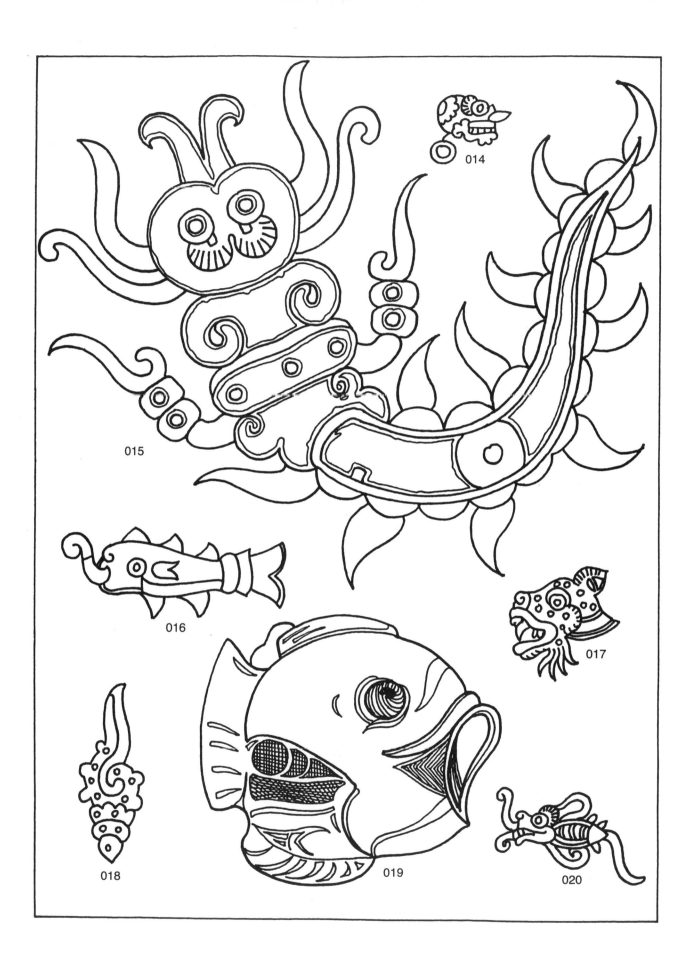

014

015

016

017

018

019

020

TOP: Detail of centipede; Otates, Veracruz. BOTTOM: Effigy jar; Tlatilco.
ALL OTHERS: Details, from various Mixtec codices.

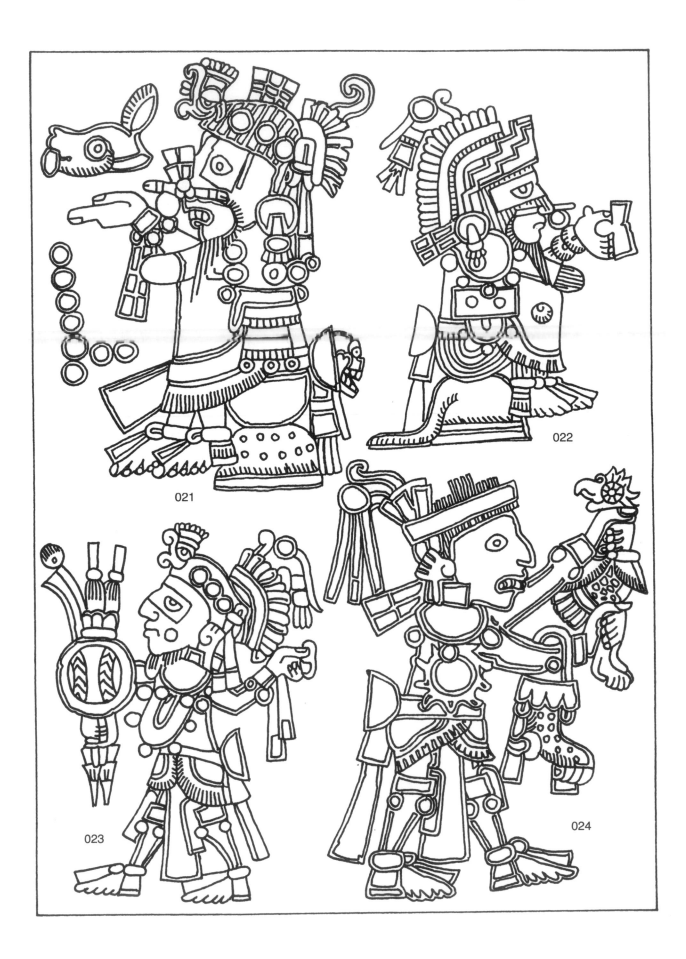

021 022 023 024

Figures, from the story of Eight-Deer, ruler of Tilantango, as recorded in Mixtec codices.

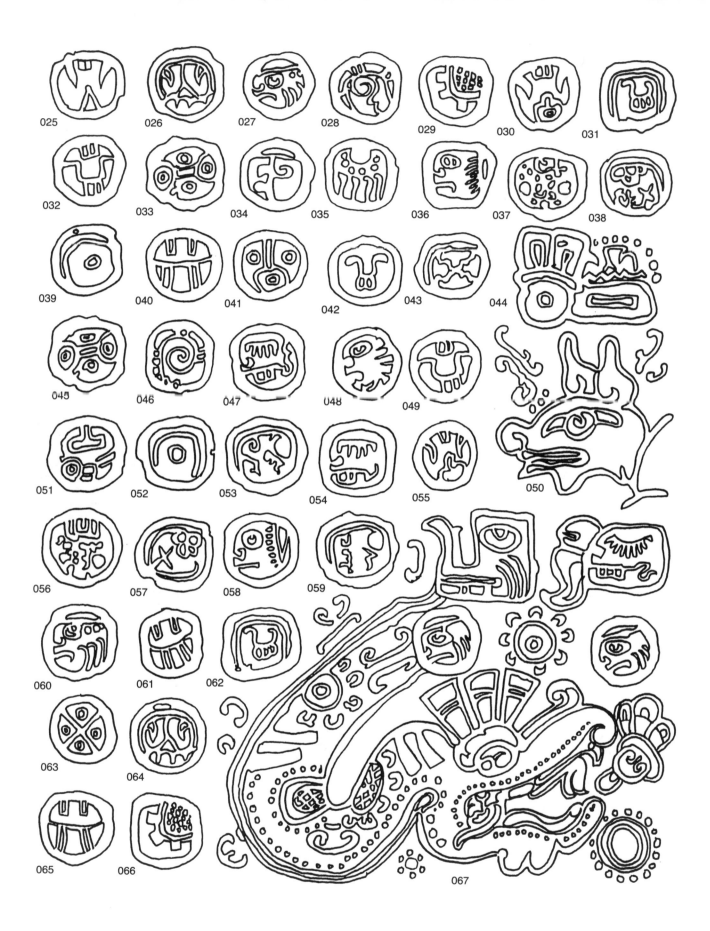

025 026 027 028 029 030 031
032 033 034 035 036 037 038
039 040 041 042 043 044
045 046 047 048 049 050
051 052 053 054 055
056 057 058 059
060 061 062
063 064
065 066 067

Details, from Florentine and Madrid codices.

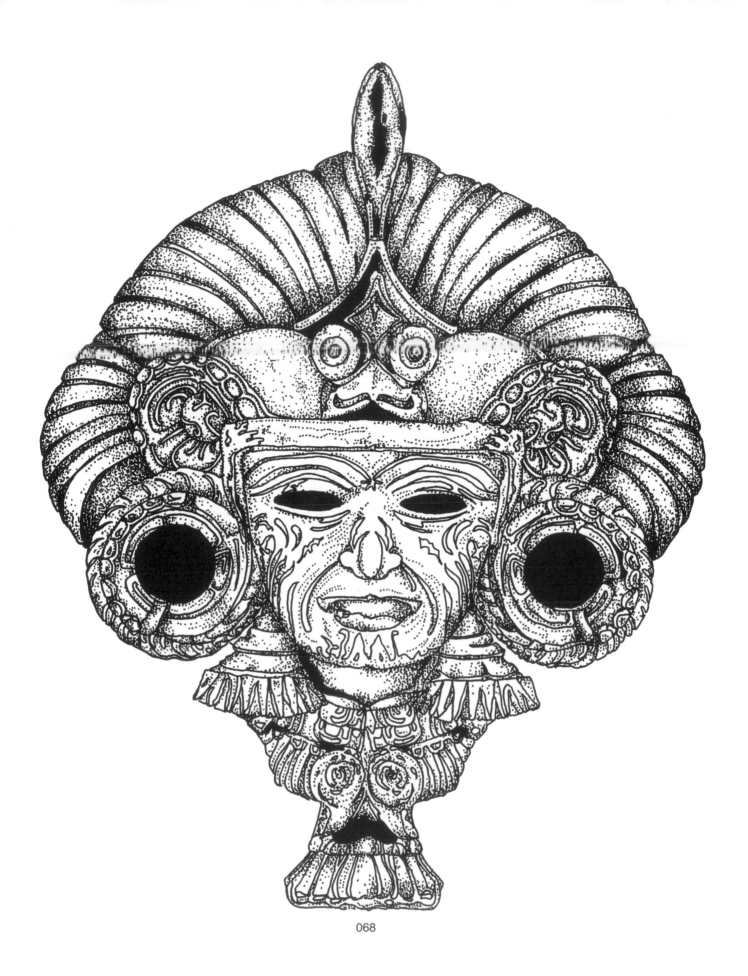

068

Clay face of Quetzalpapalotl, Aztec butterfly god.

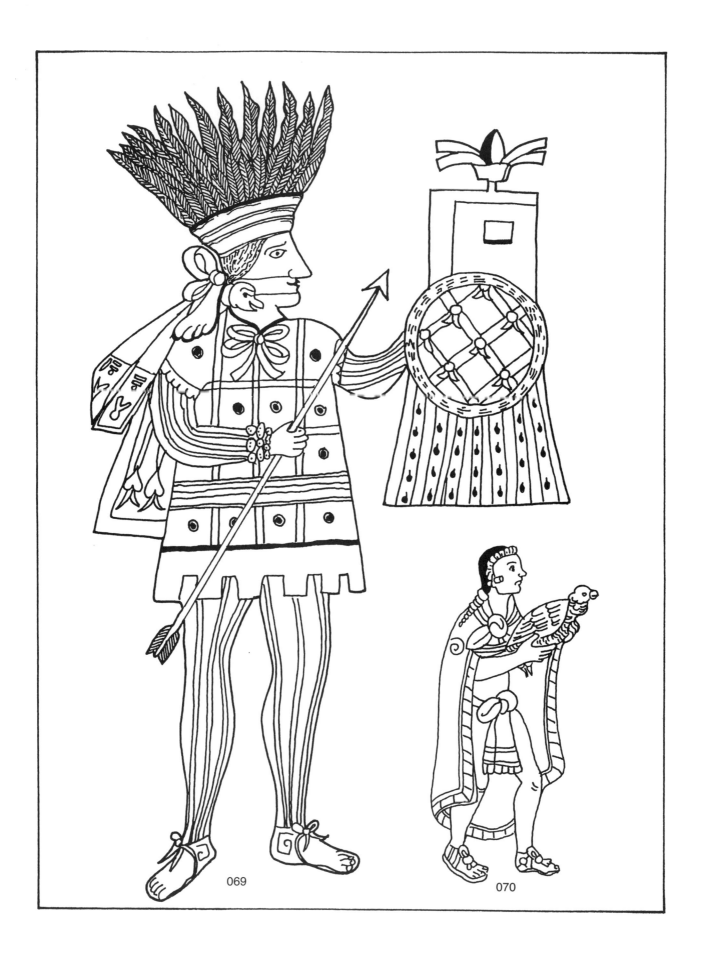

069

070

LEFT: Huitzilopochtli, Aztec god of war, from Vienna Codex.
RIGHT: Rendering of a Tlaxcala warrior, one of the Aztecs' rivals.

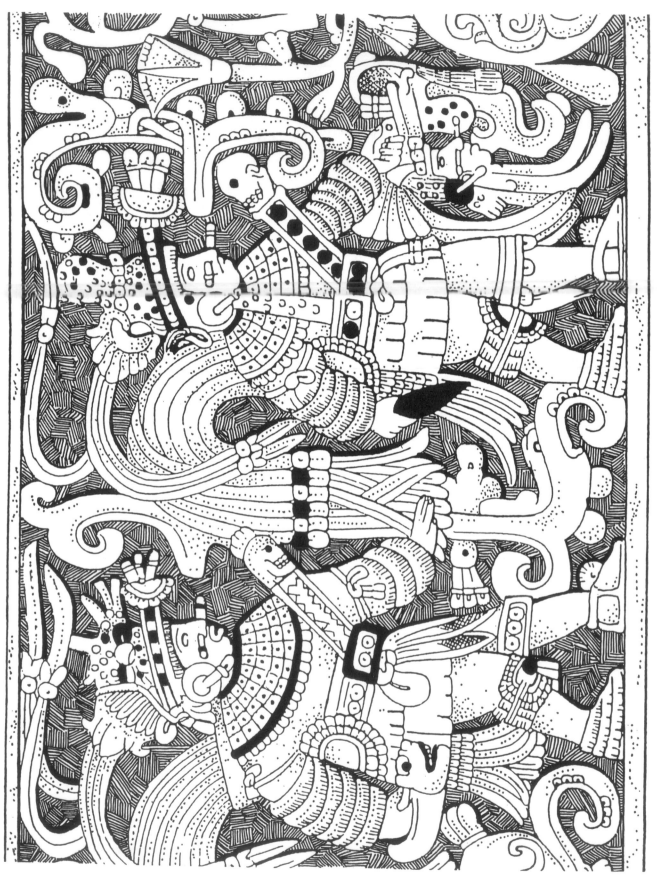

071

Bas-relief fragment; Chichén Itzá.

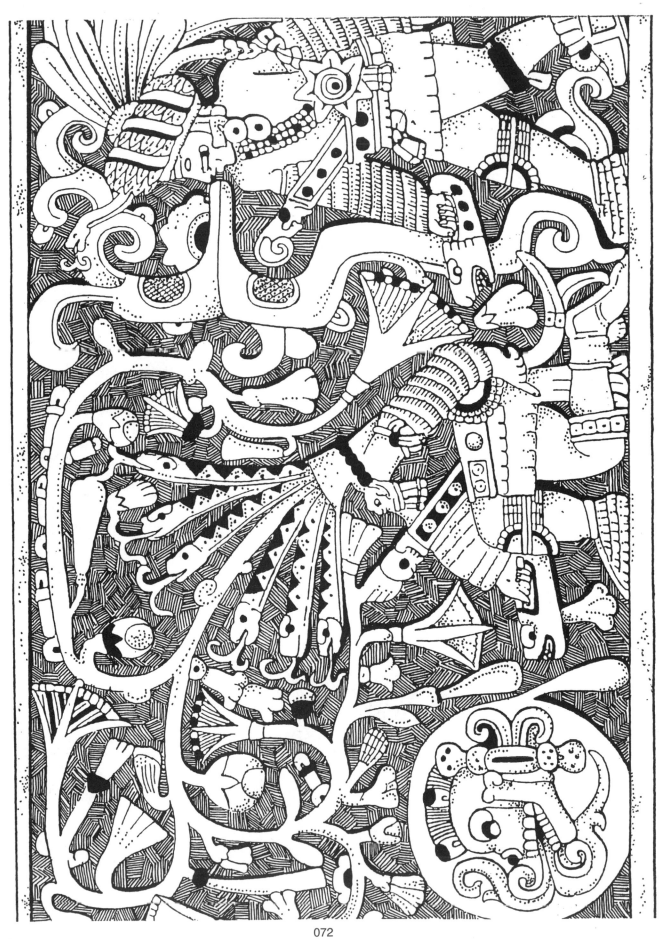

072

Bas-relief fragment; Chichén Itzá.

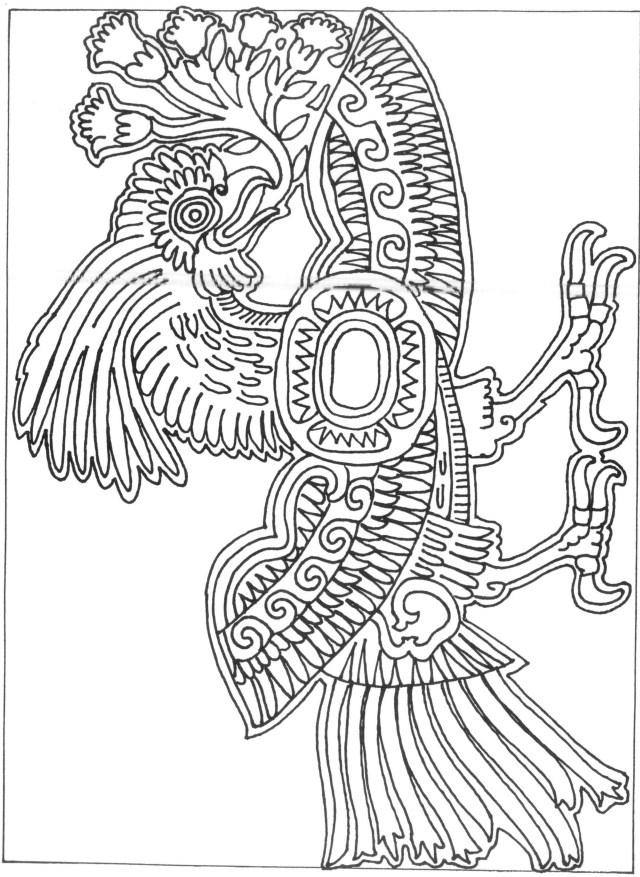

073

Quetzal bird, wall painting; Teotihuacán.

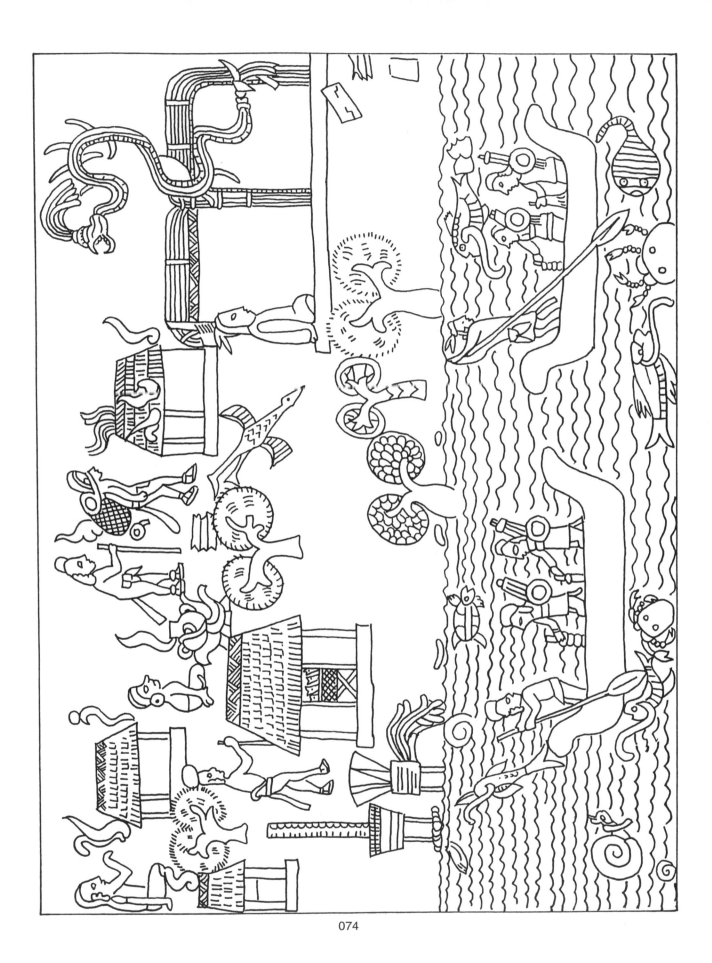

074

Detail from wall painting; Chichén Itzá.

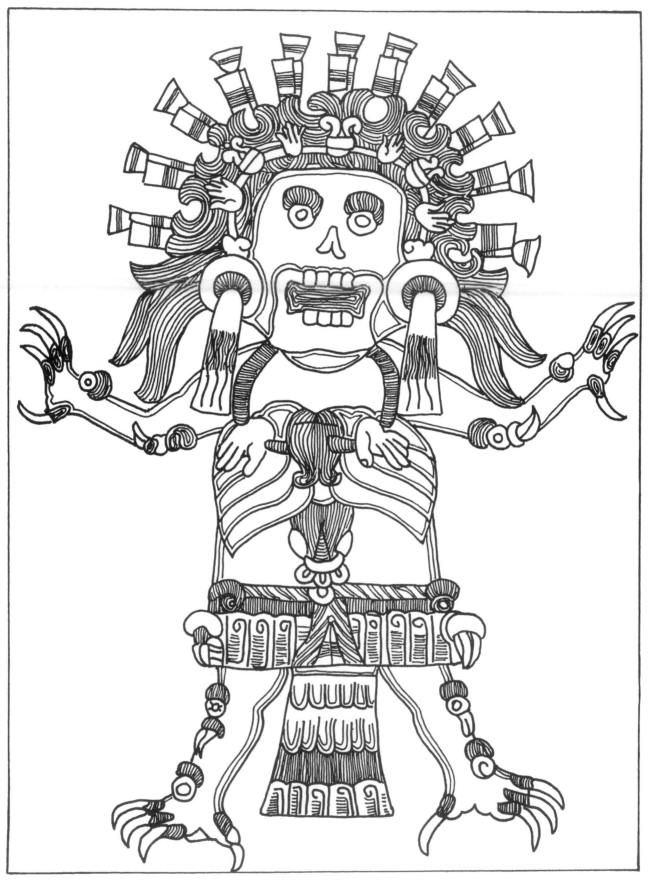

075

Aztec god of medicine, detail from Tudela Codex.

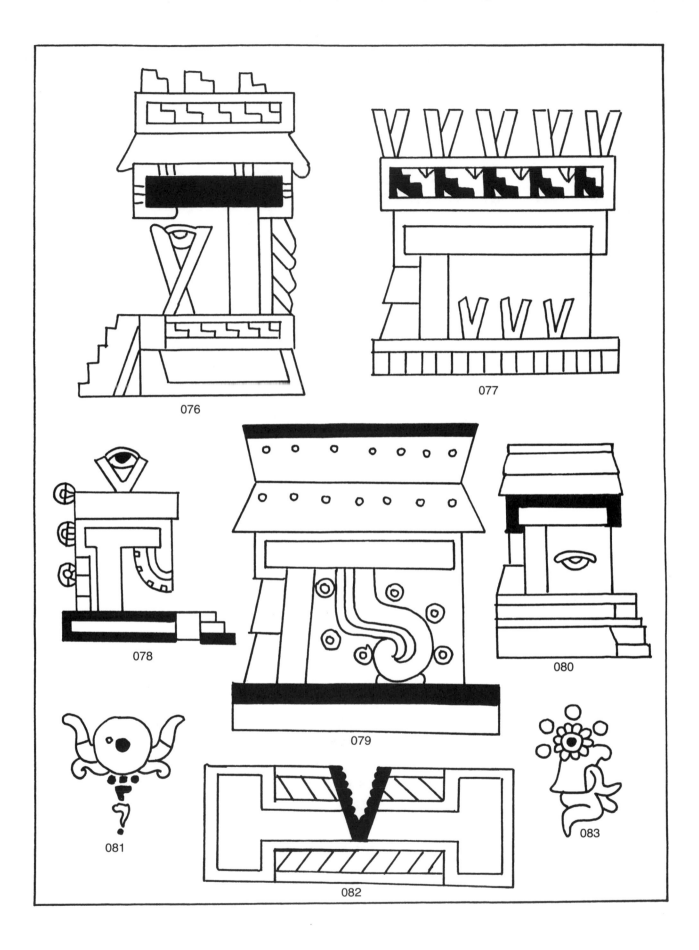

076

077

078

079

080

081

082

083

Architectural details, from various codices.

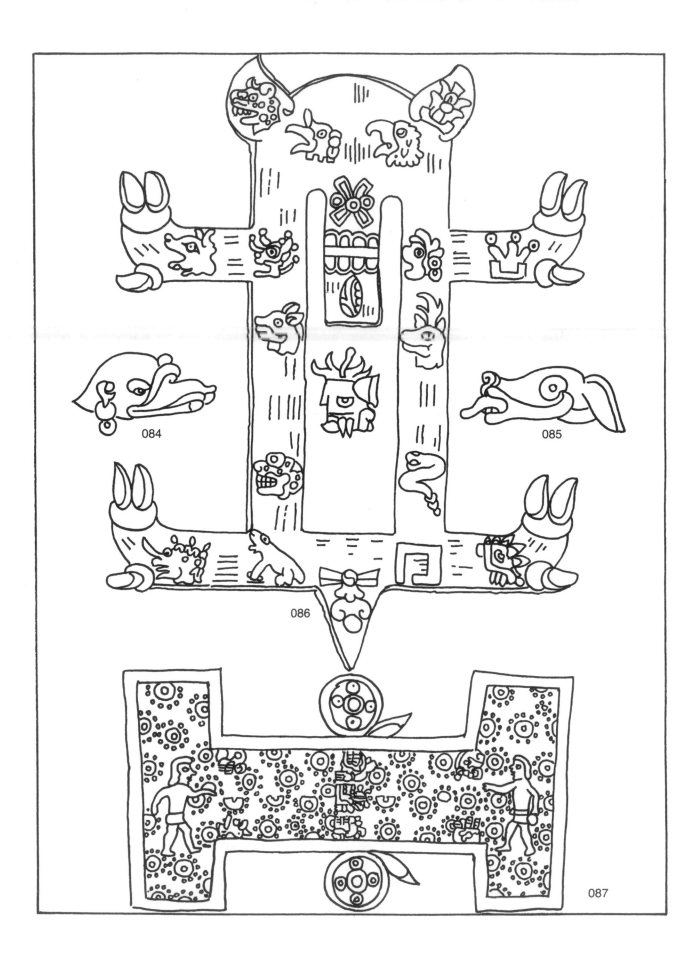

084

085

086

087

TOP: Aztec calendar, from Tudela Codex. BOTTOM: Aztec ball-court, from Bourbon Codex.
LEFT AND RIGHT: Figures, from various Mixtec codices.

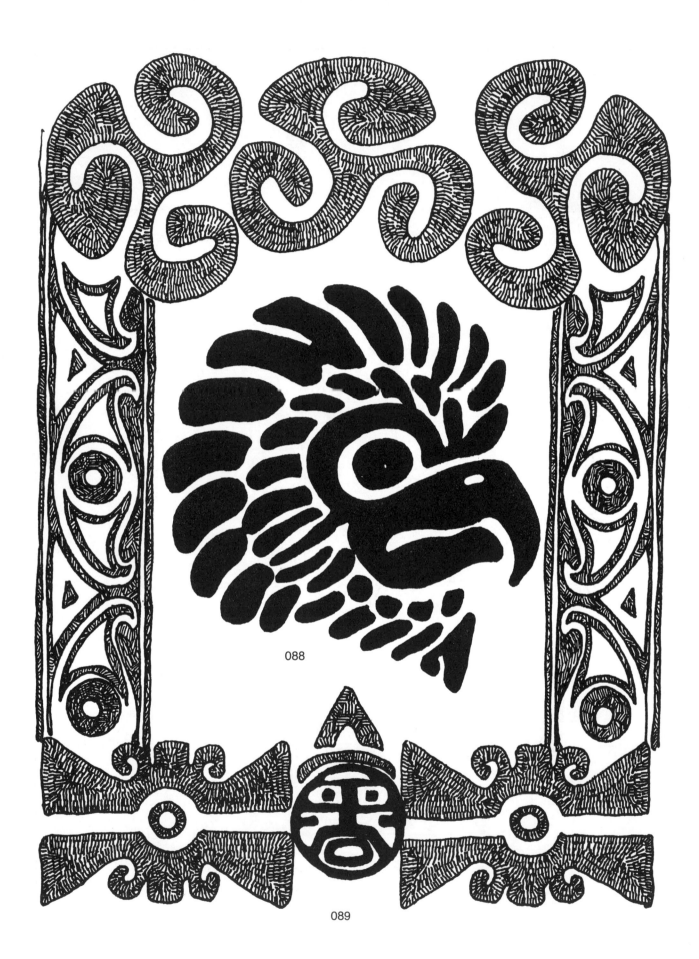

088

089

Design incorporating ancient Mexican seals.

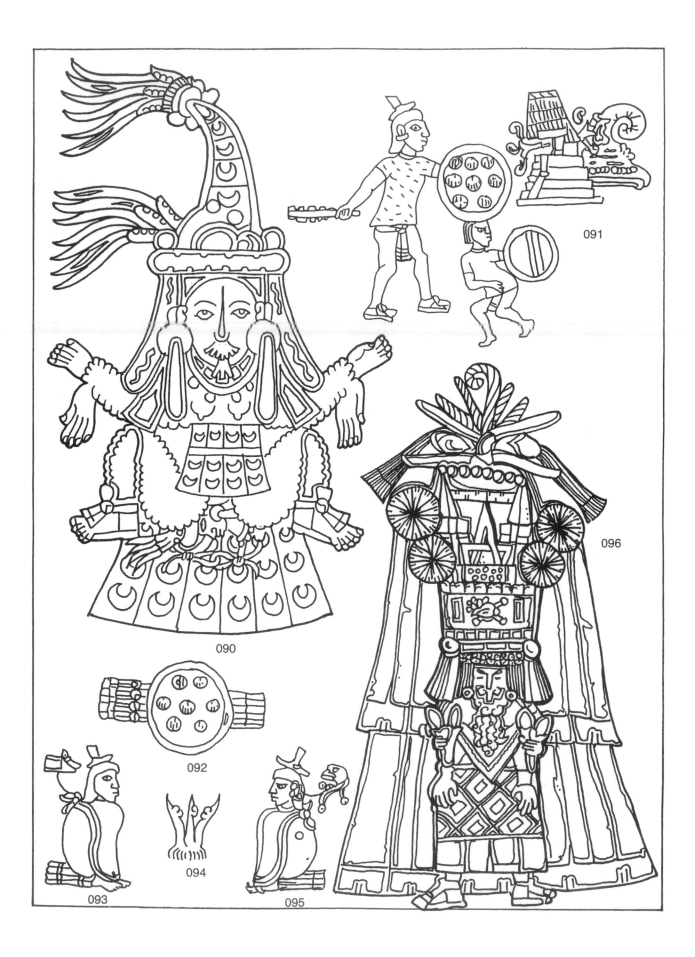

091

096

092

093 094 095 090

TOP, LEFT: Tlazoltéotl, Aztec goddess, from manuscript fragment.
TOP, RIGHT; MIDDLE LEFT: Detail from Aztec manuscripts. BOTTOM, RIGHT: Ceremonial figure, from Bourbon Codex.

19

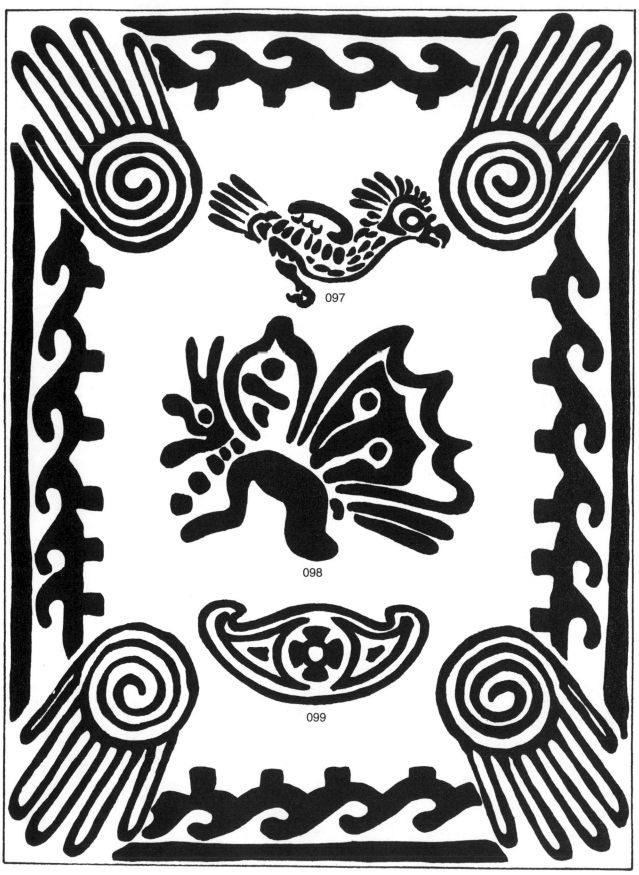

Design incorporating ancient Mexican seals.

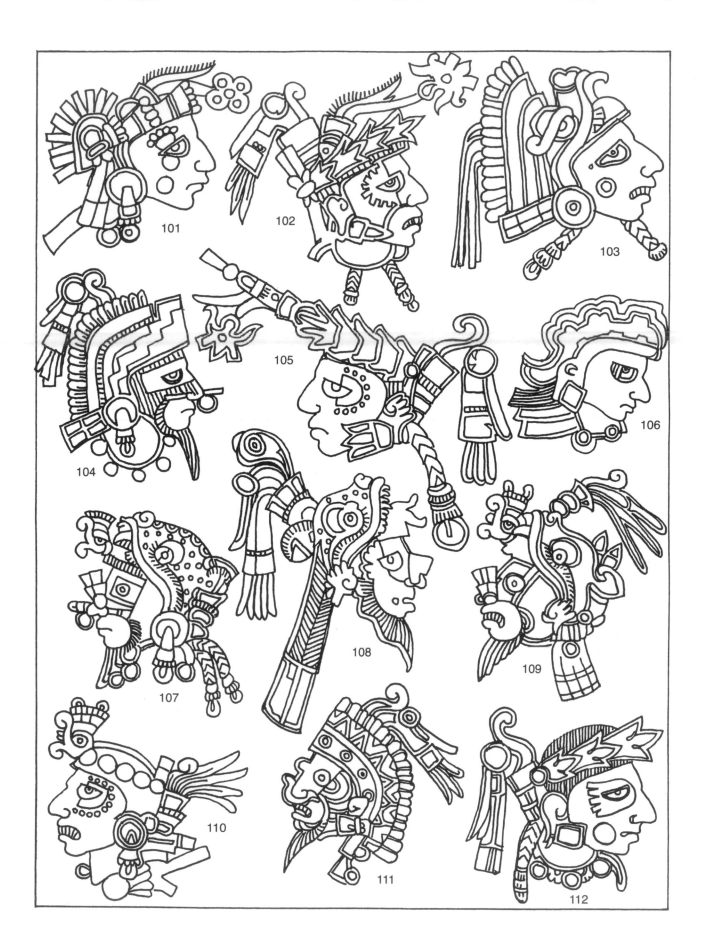

Faces, from various codices.

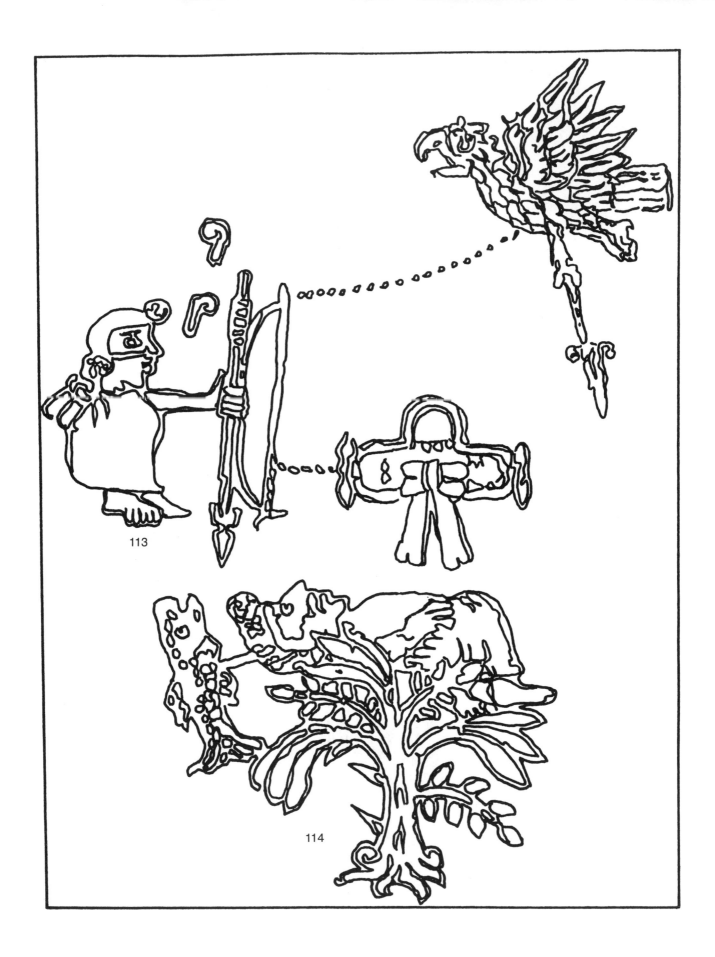

113

114

Details, from Madrid Codex.

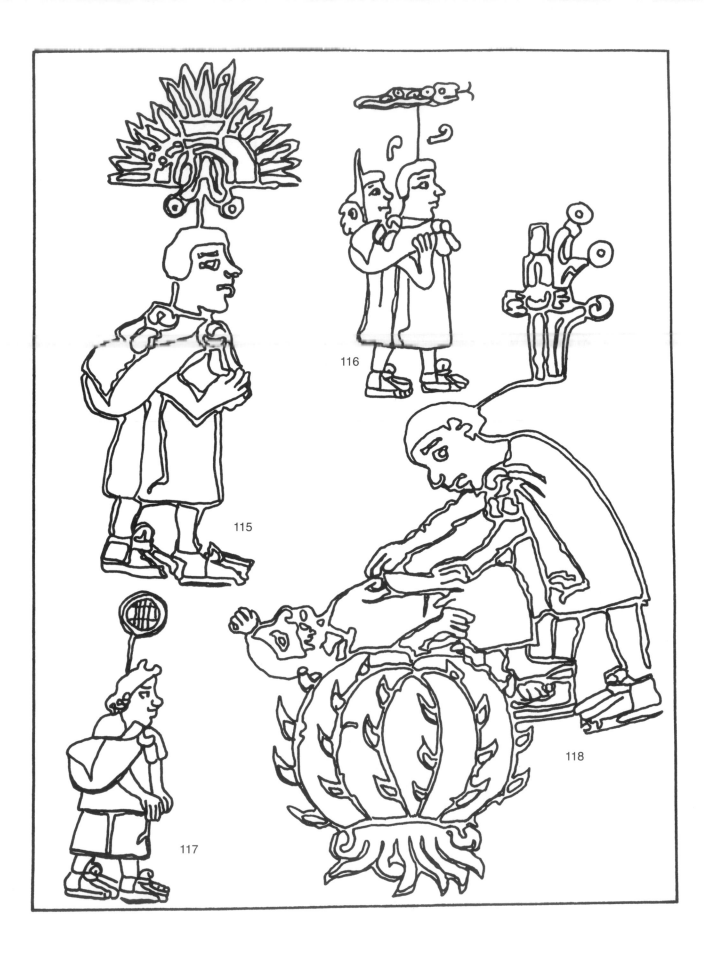

Figures, from Madrid Codex.

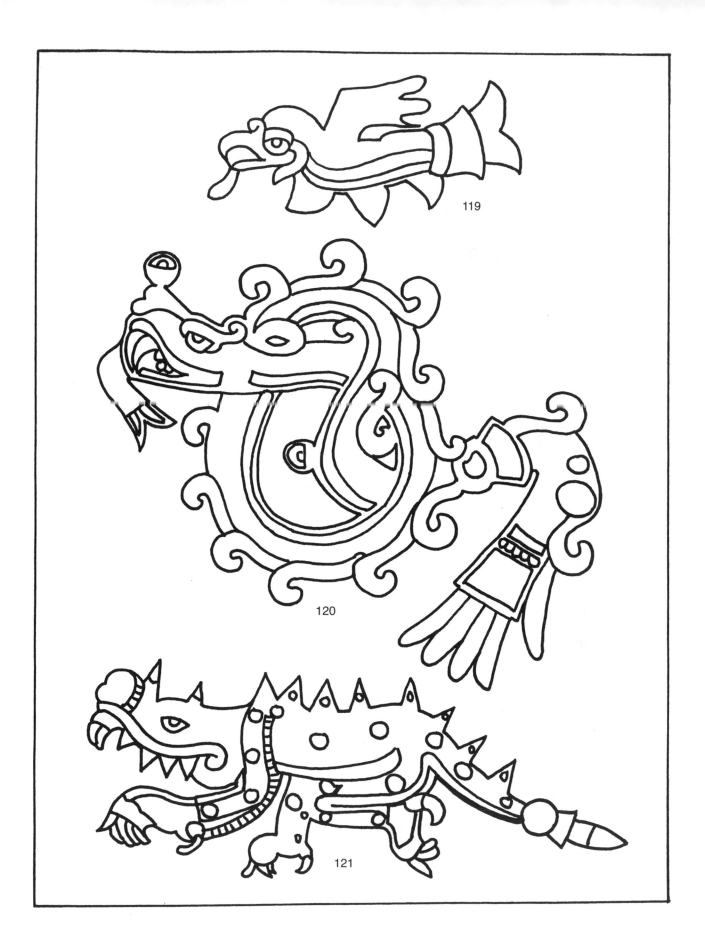

119

120

121

Animals, from the story of Eight-Deer, Mixtec codices.

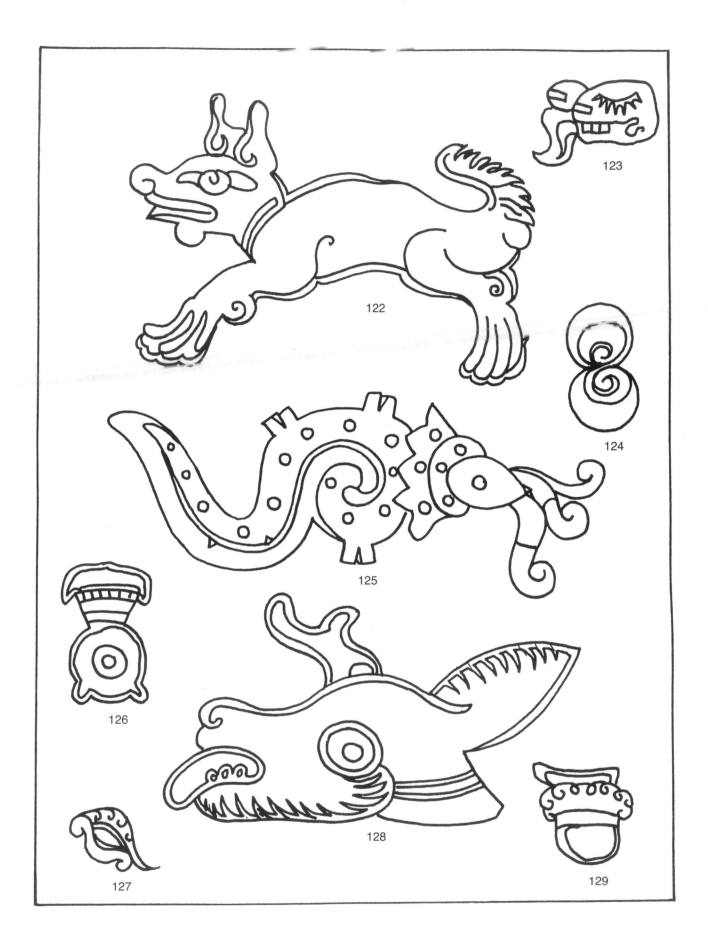

TOP: Animal, from Florentine Codex. ALL OTHERS: Details of animals and other figures, from the story of Eight-Deer, Mixtec codices.

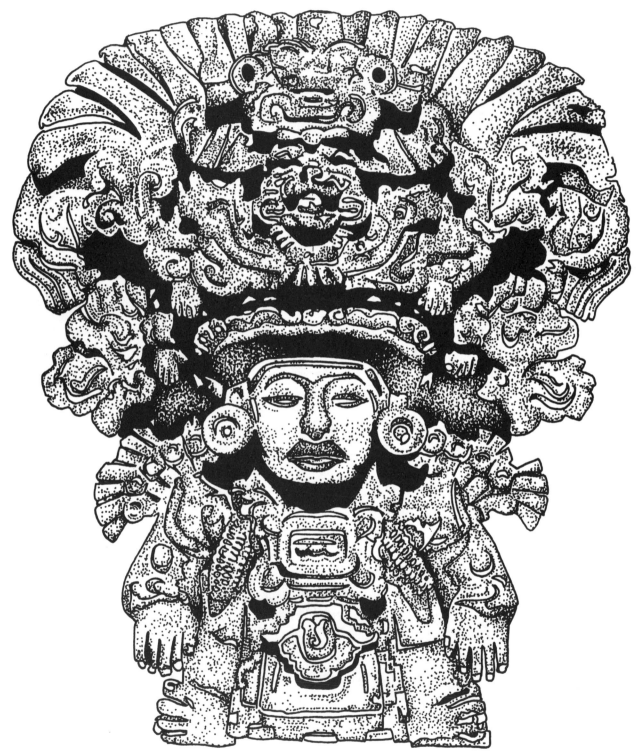

130

Zapotec god of maize.

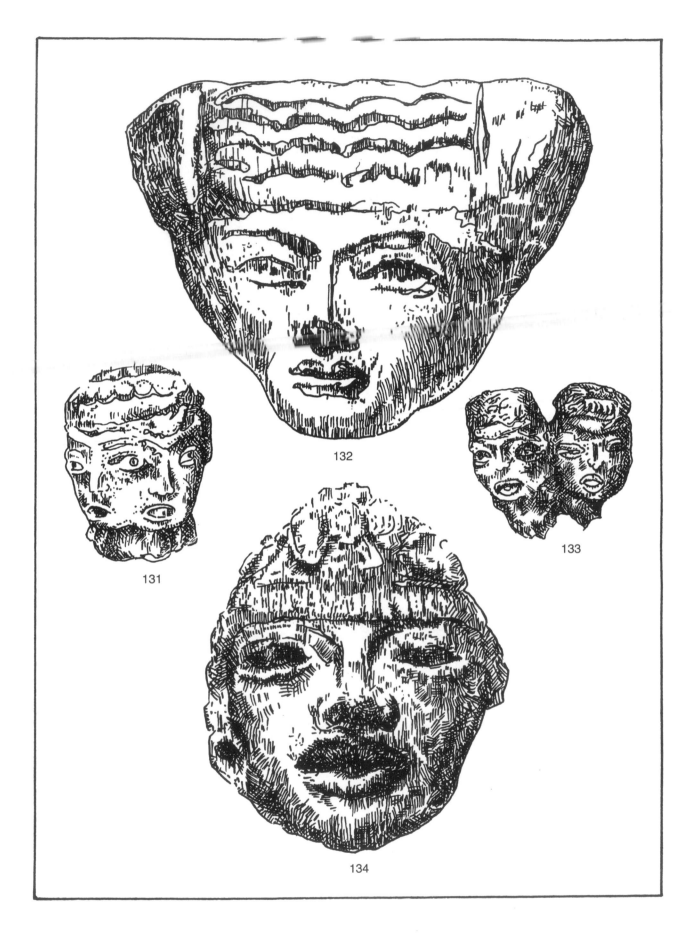

131

132

133

134

Heads; Teotihuacán.

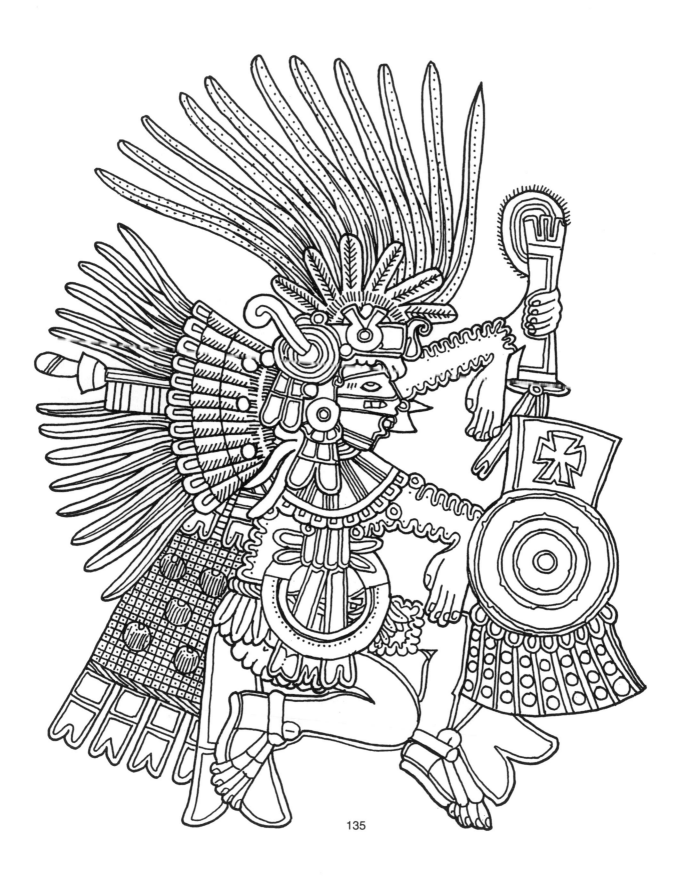

135

Aztec god of war, from Bourbon Codex.

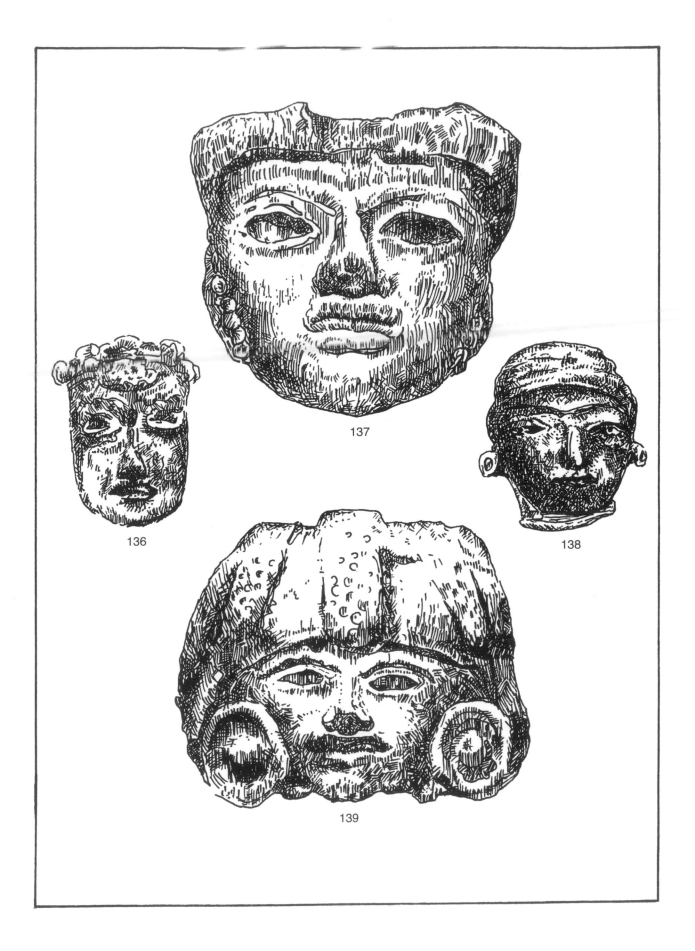

136

137

138

139

Heads; Teotihuacán.

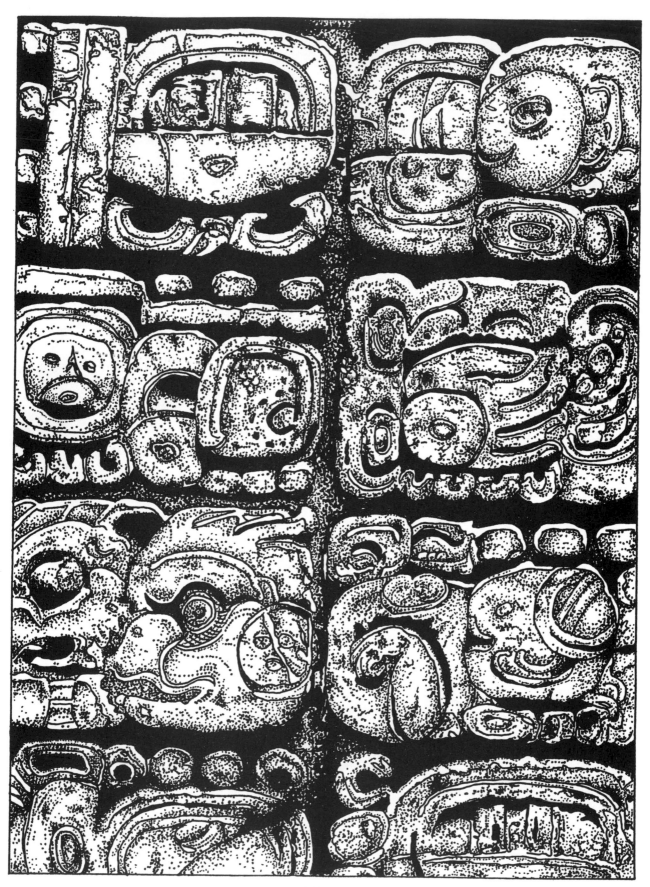

140

Mayan hieroglyphs; Palenque.

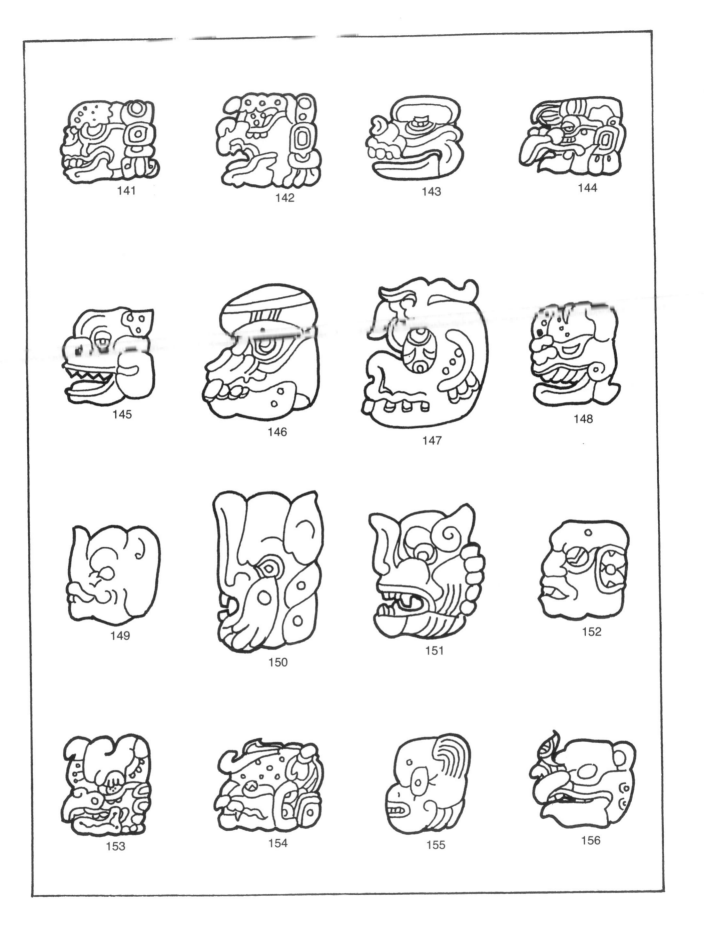

Mayan hieroglyphs.

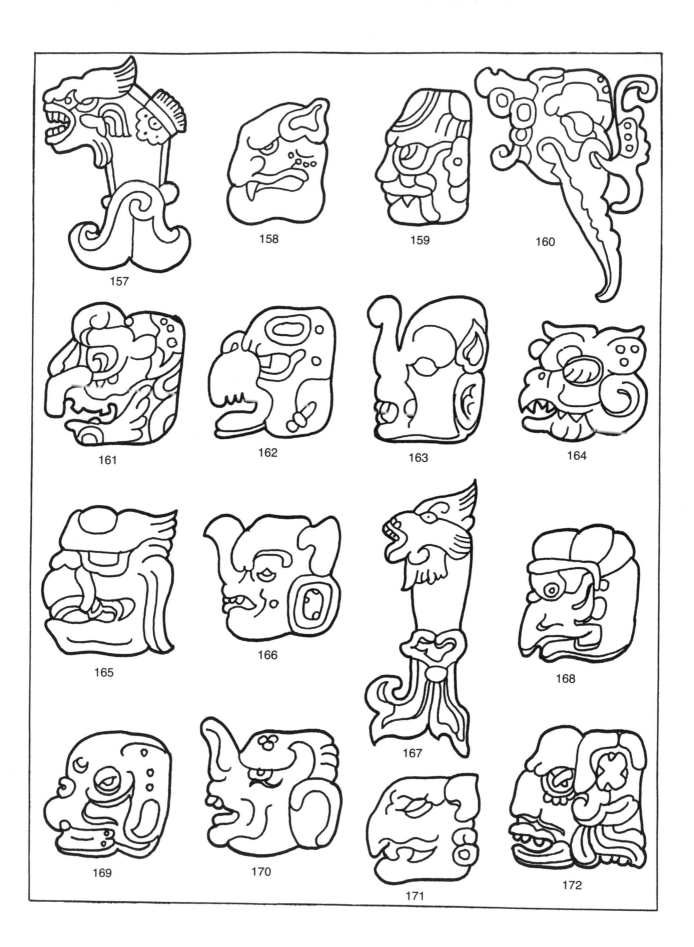

Mayan hieroglyphs.

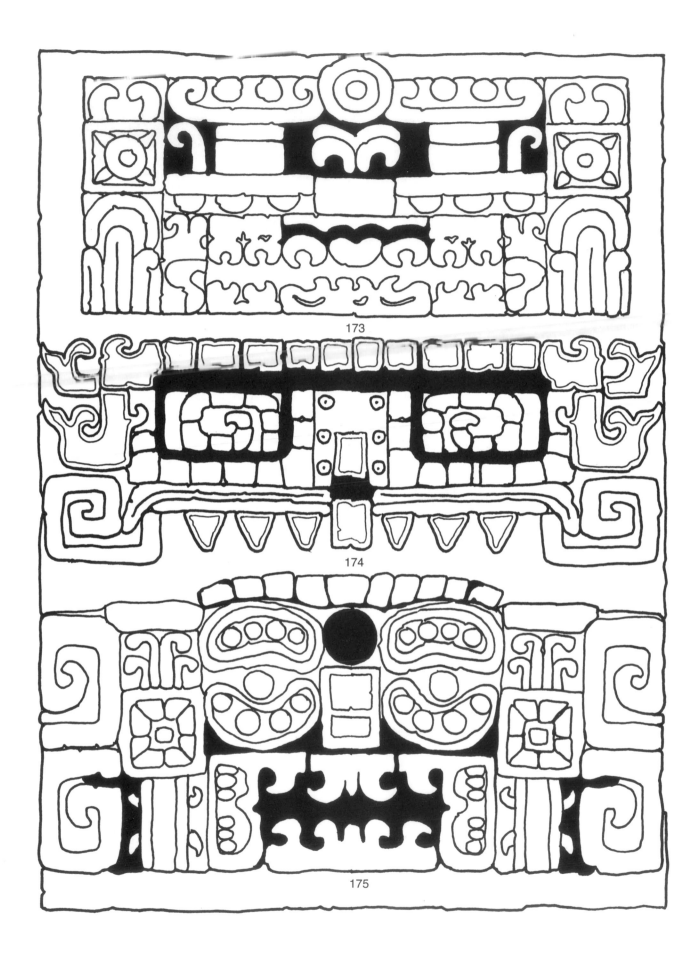

173

174

175

Mask panels from various temples.

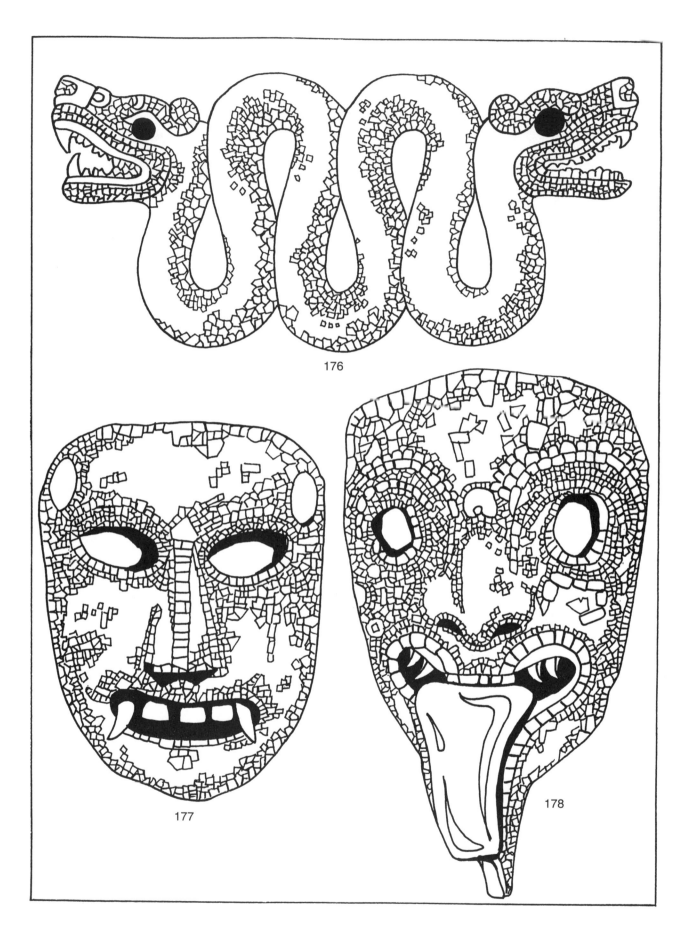

176

177

178

TOP: Snake pectoral ornament associated with the Aztec god Huitzilopochtli.
BOTTOM, LEFT: Mask of Quetzalcóatl. BOTTOM, RIGHT: Aztec mask.

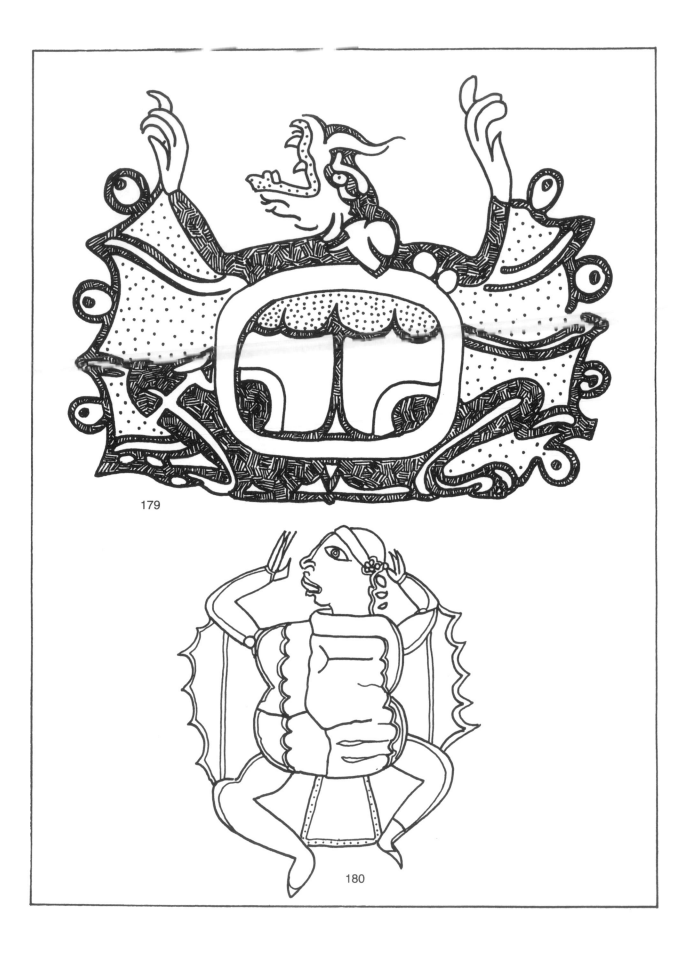

179

180

TOP: Mayan Bat god. BOTTOM: Mayan dancer disguised as Bat god.

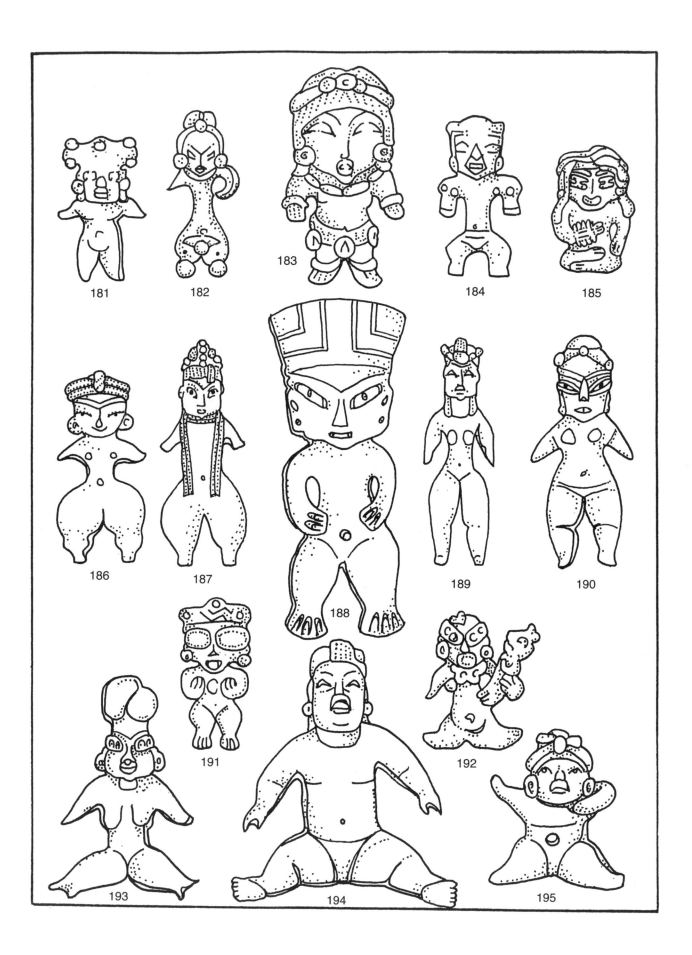

Clay figurines, Pre-Classic Era.

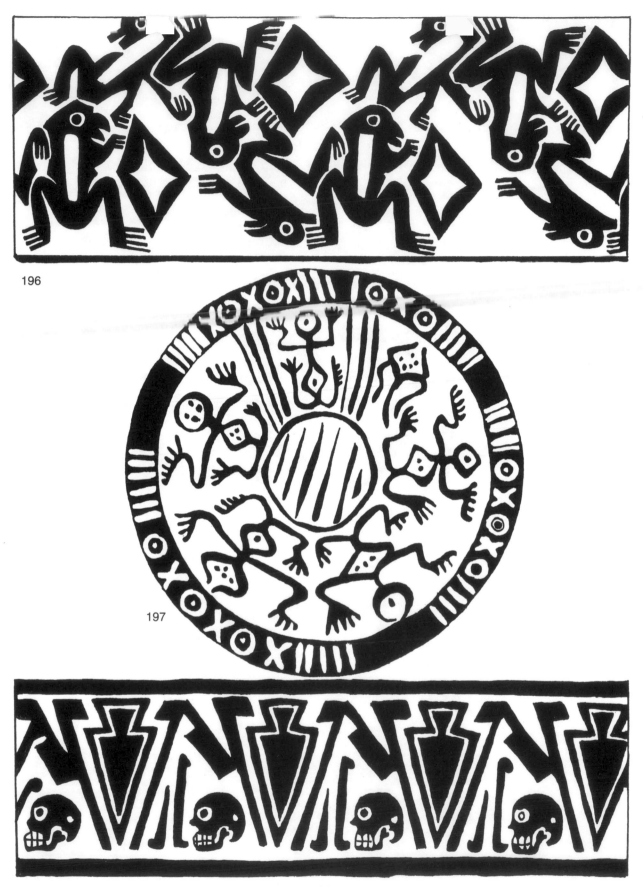

196

197

198

TOP: Zacatenco cylindrical stamp; Tlatilco. MIDDLE: Tzintzúntzan bowl decoration.
BOTTOM: Body stamp; Tenochtitlán.

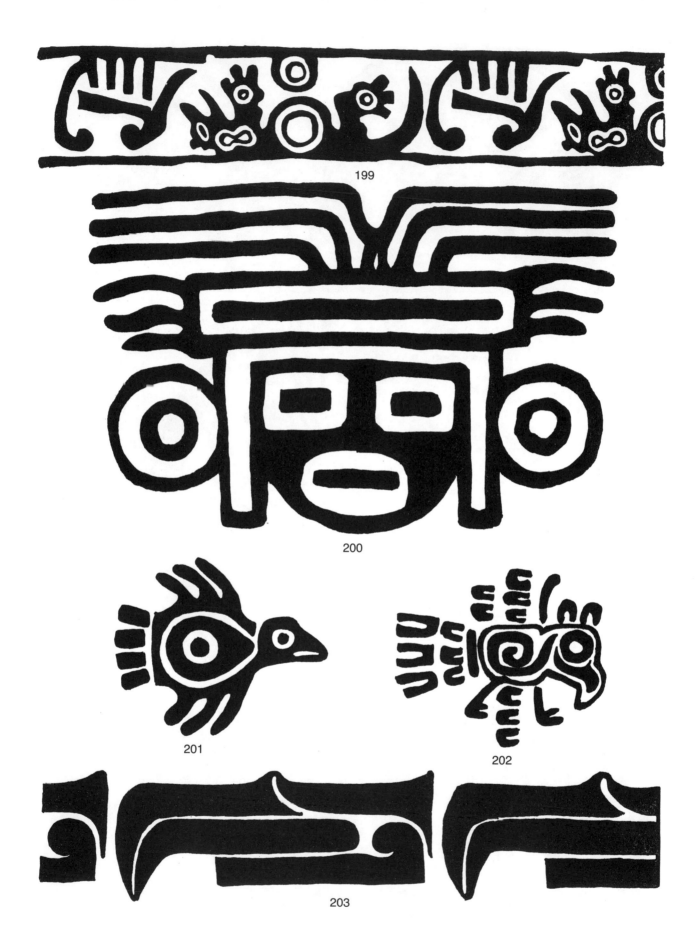

199

200

201

202

203

Row 1: Zacatenco cylindrical stamp; Tlatilco. Row 2: Body stamp; Valley of Mexico
Row 3: Left: Body stamp; Guerrero. Right: Body stamp; Valley of Mexico.
Row 4: Zacatenco cylindrical stamp; Tlatilco.

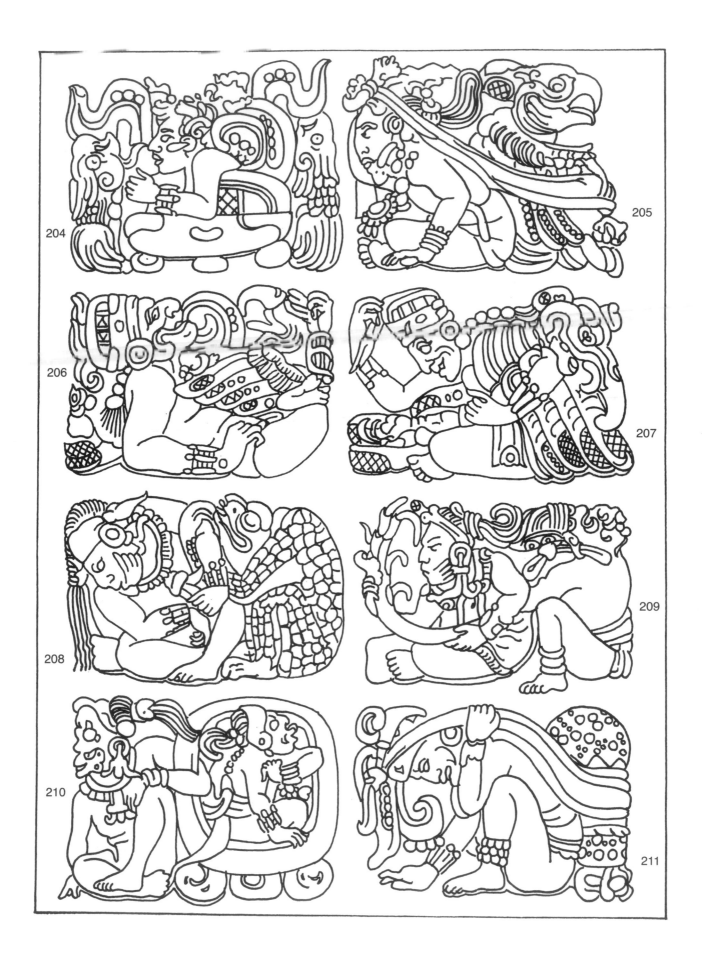

Mayan number gods.

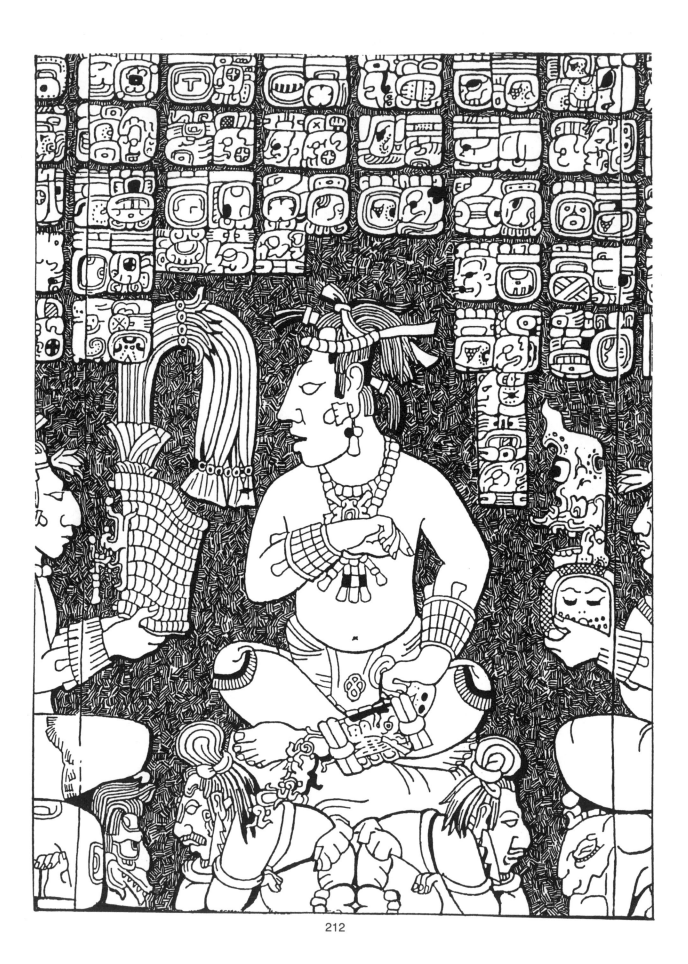

212

"Tablet of the Slaves"; Palenque.

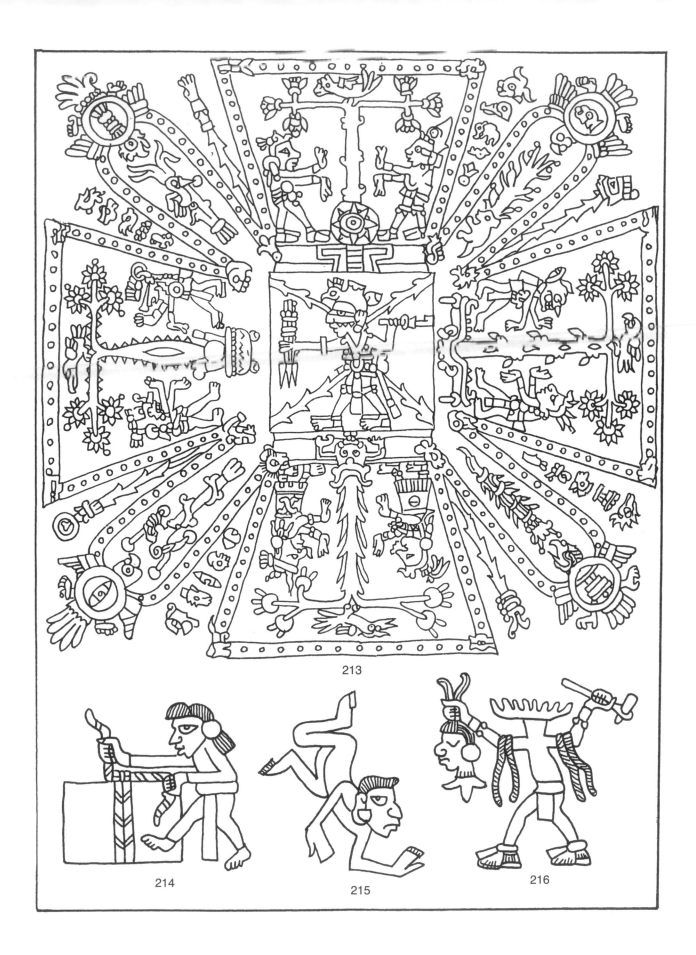

213

214

215

216

TOP: "The Four Regions of the Universe," Aztec, from Fejérváry-Mayer Codex.
BOTTOM: Details, from Mixtec codices.

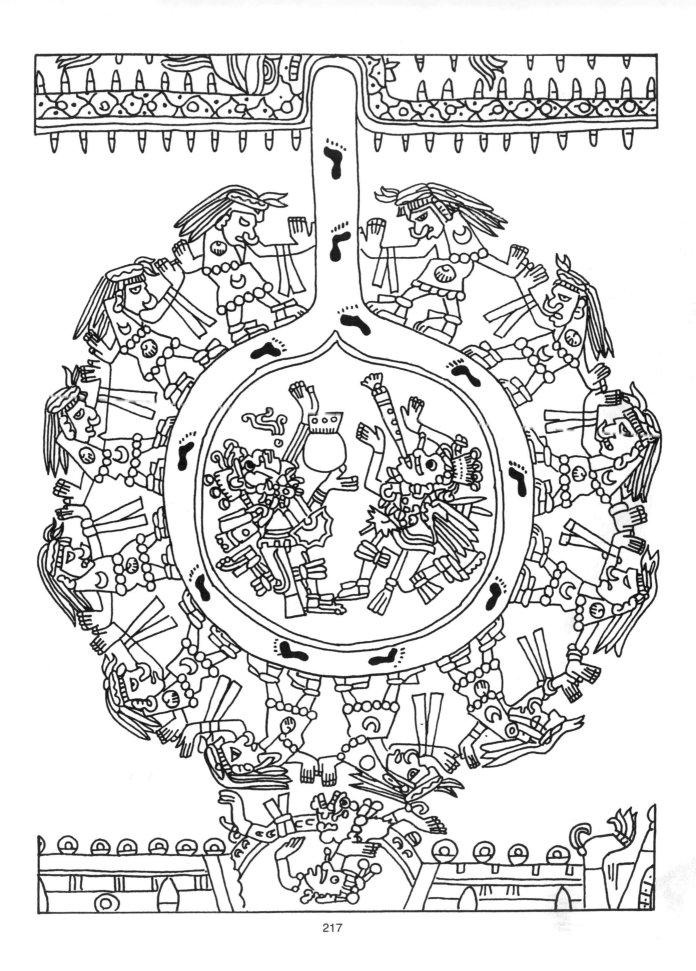

217

Drawing of sacred dance of 12 *cihuateteo* (women who died in childbirth), cult of Quetzalcóatl.

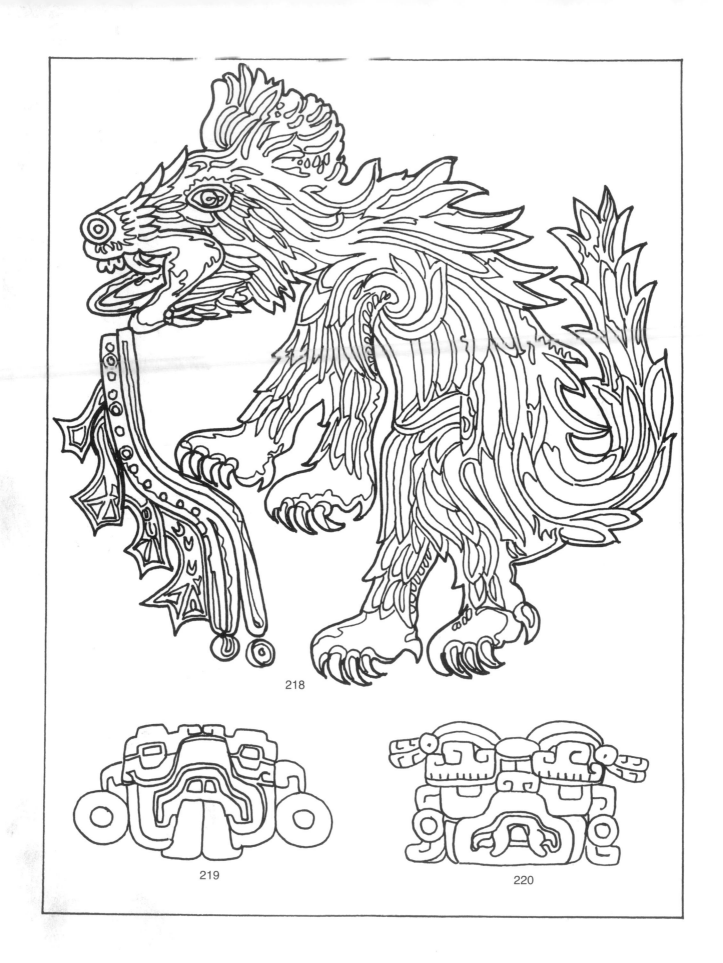

218

219

220

Top: Detail from Aztec shield representing King Ahuizotl. Bottom: Rain gods; Monte Albán, Teotihuacán.

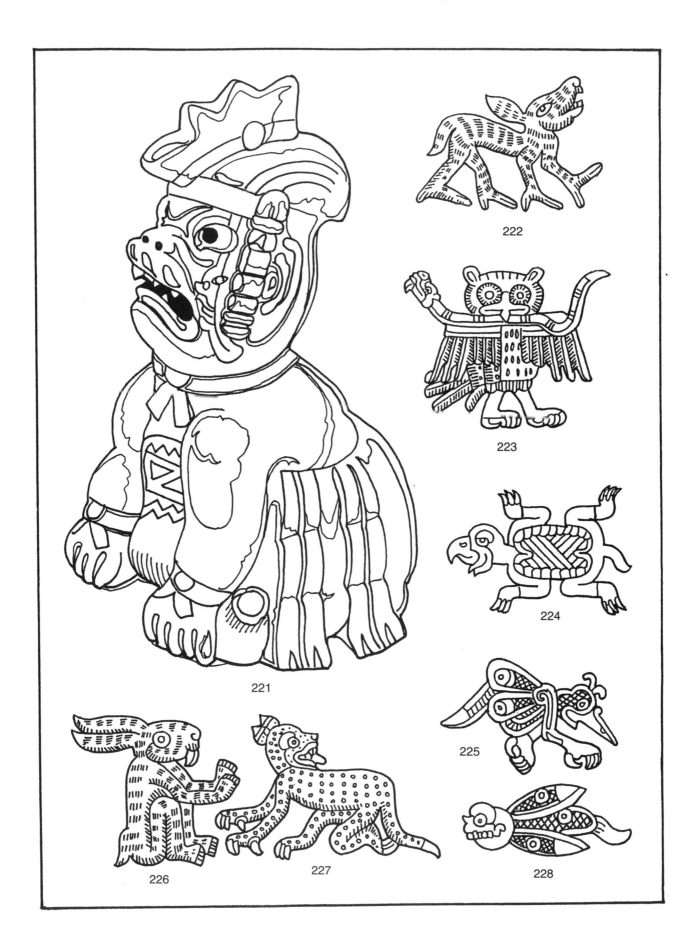

221 222 223 224 225 226 227 228

TOP, LEFT: Olmec pottery figure. RIGHT AND BOTTOM: Human and animal Mixtec motifs, from Borgia, Nuttall, and Vienna codices.

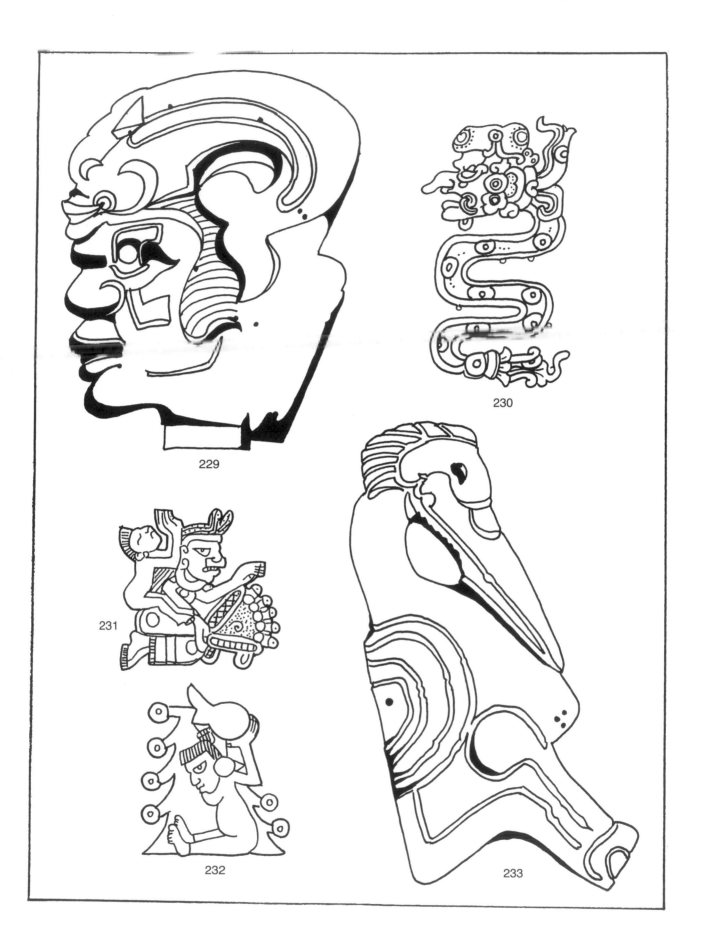

TOP, LEFT: Head of a young man wearing dolphin helmet; San Andres, Tuxtla.
BOTTOM, RIGHT: Pelican figure; Coatepec. TOP, RIGHT; BOTTOM, LEFT: Motifs from Borgia,
Nuttall, and Vienna codices.

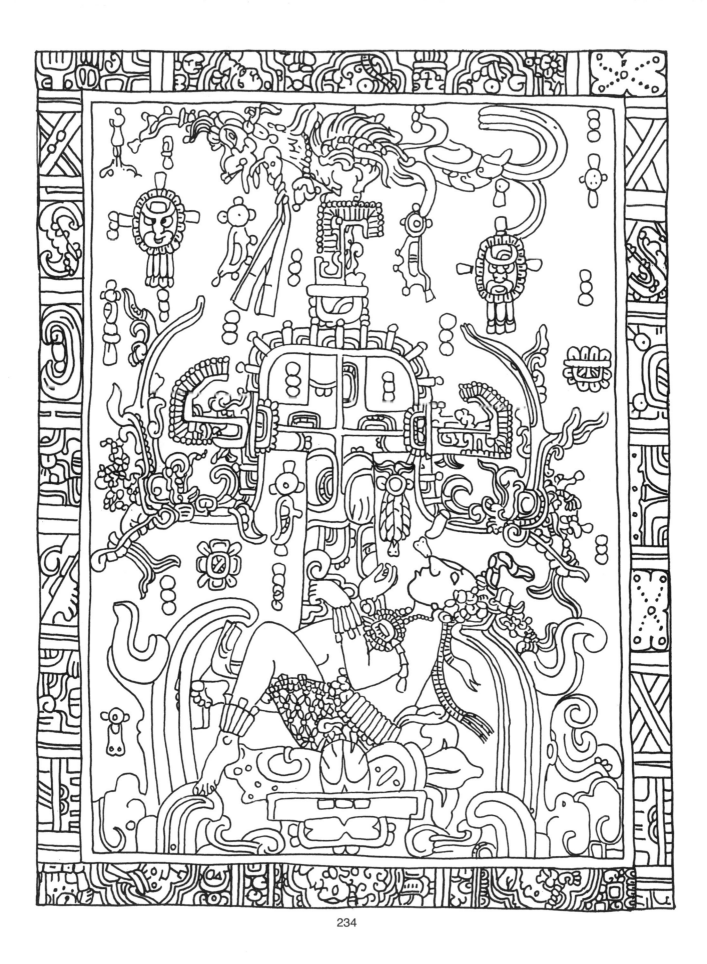

234

Mayan relief carving on a sarcophagus of a young king; Palenque.

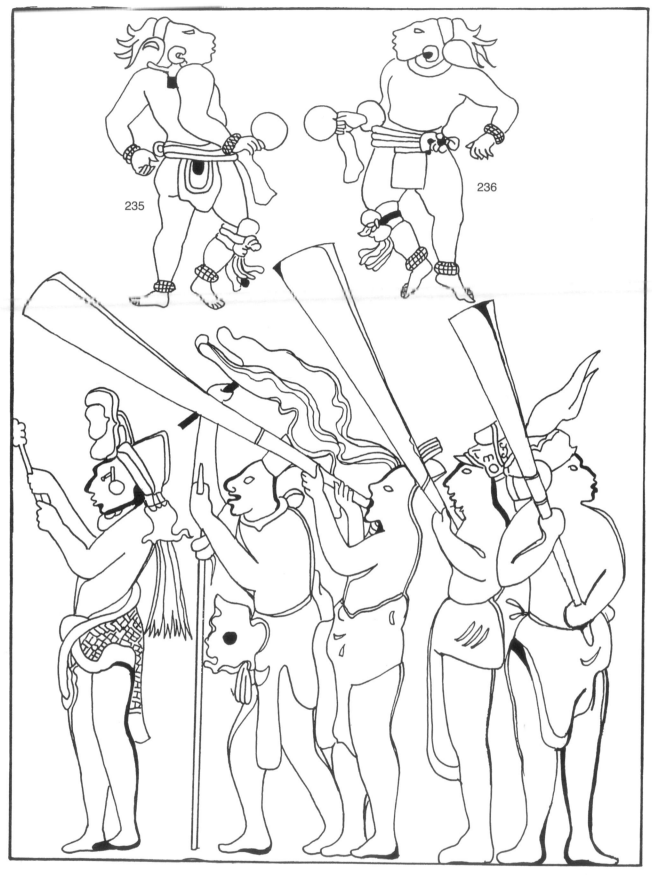

235

236

237

TOP: Ritual dance of ballplayers, Mayan stone relief; Piedras Negras.
BOTTOM: Mayan trumpet players, fresco; Bonampak.

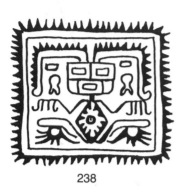

238

239

240

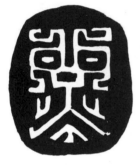

241

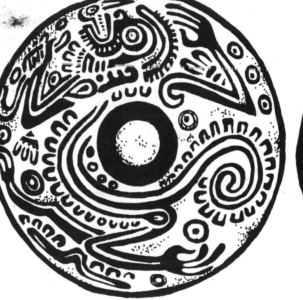

242

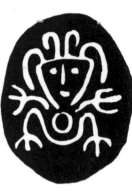

243

244

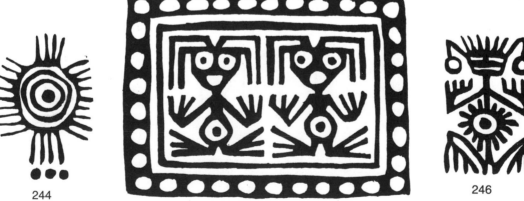

245

246

TOP, MIDDLE, AND CENTER: Aztec spindle whorls. ALL OTHERS: Impressions from clay seals; Guerrero.